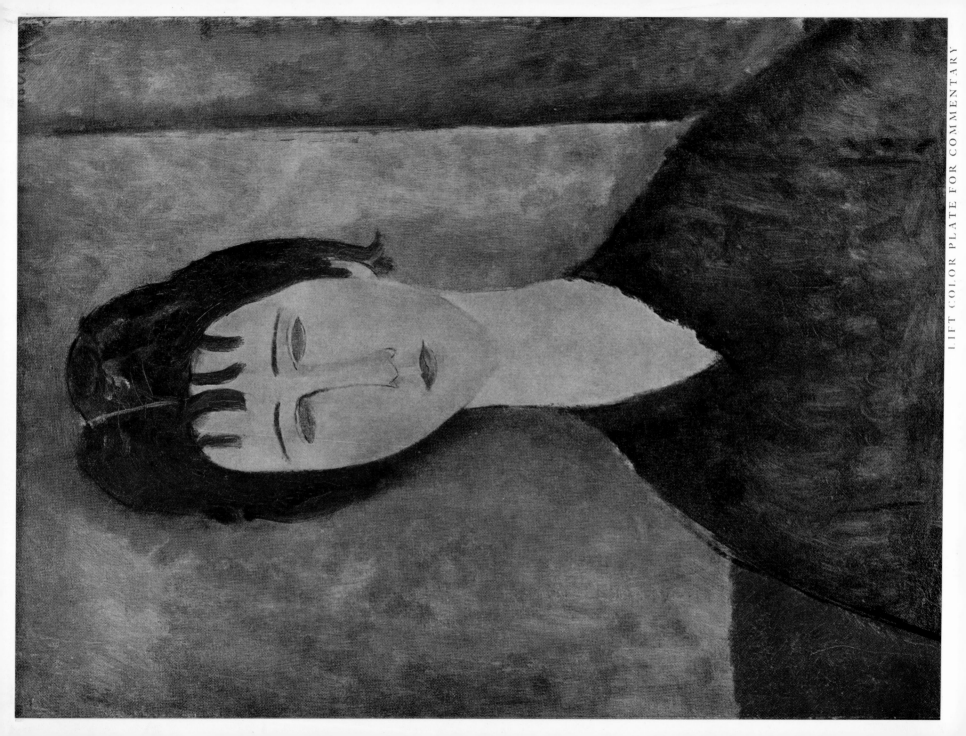

Amedeo Modigliani

GREAT ART OF THE AGES

Amedeo

GREAT ART OF THE AGES

Modigliani

Text by Jacques Lipchitz

Commentaries by Alfred Werner

Harry N. Abrams, Inc. Publishers New York

ON THE COVER:

(*Front*) Girl with Braids. 1917
Collection Dr. and Mrs. Ernest Kahn, Cambridge, Mass.
(*Back*) Yellow Sweater (Portrait of Mlle. Hébuterne). c. 1919
The Solomon R. Guggenheim Museum, New York

MILTON S. FOX, *Editor-in-Chief*
Standard Book Number: 8109-5124-x
Library of Congress Catalog Card Number: 69-19711

Amedeo Modigliani

(1884–1920)

FOR SOME STRANGE REASON, when I think of Modigliani now, I always associate him with poetry. Is it because it was the poet Max Jacob who introduced me to him? Or is it because when Max introduced us—it was in the Luxembourg Gardens in Paris, in 1913—Modigliani suddenly began to recite by heart the *Divine Comedy* at the top of his voice?

I remember that, without understanding a word of Italian, I was fascinated by his melodious outburst and his handsome appearance: he looked aristocratic even in his worn-out corduroys. But even after I had known him a long time, Modigliani would surprise us often with his love for poetry—sometimes at the most awkward moments.

I recall a scene, one night (it must have been in 1917) very late, maybe three o'clock in the morning. We were suddenly aroused from our sleep by a terrific pounding on the door. I opened. It was Modigliani, obviously quite drunk. In a shaky voice he tried to tell me he remembered seeing on my shelf a volume of poetry by François Villon and he said he would like to have it. I lighted my kerosene lamp to find the book, hoping that he would leave so that I could go back to sleep. But no; he settled down in an armchair and began to recite in a loud voice.

I was living at that time at 54 Rue du Montparnasse in a house occupied by working people, and soon my neighbors began to knock on the walls, on the ceiling, on the floor of my room, shouting, "Stop that noise!" This scene is still vivid in my mind: the small room, the darkness of the middle of the night interrupted only by the flickering, mysterious light of the kerosene lamp, Modigliani, drunk, sitting like a phantom in the armchair, completely undisturbed, reciting Villon, his voice growing louder and louder, accompanied by an orchestra of knocking sounds from all around our little cell. Not until he exhausted himself, hours later, did he stop. We often discussed poetry—Baudelaire, Mallarmé, Rim-

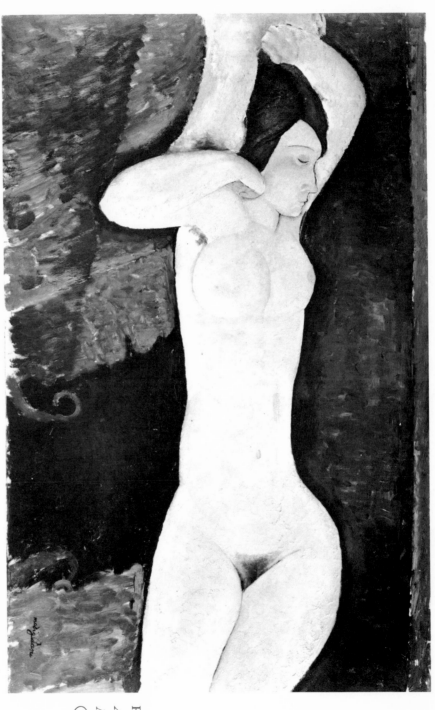

Max's sufferings in the concentration camp of Drancy early in the German occupation of France, when I read about him lying among other martyrs on the dirty floor, dying slowly and painfully, immediately the scene in the Luxembourg Gardens came vividly to mind.

The *Divine Comedy* recited by Modigliani and the hell suffered by Max Jacob together make a pathetic image worthy of Modigliani's memory. He knew what it was to suffer, too. He was sick with tuberculosis which killed him; he was hungry and poor. But he was at the same time a *riche nature*—so lovable, so gifted with talent, with sensitivity, with intelligence, with courage. And he was generous—promiscuous, even—with his gifts, which he scattered recklessly to the winds in all the hells and all the artificial paradises.

Before I was introduced to him, I had frequently seen Modigliani in cafés and on the streets of Montparnasse. A friend of mine, Cesare Sofianopulo, painter and poet from Trieste who was one of my fellow students at the Académie Julian in 1911 and whose portrait I made at this time, reminded me in a letter just before the Second World War that Modigliani went to school with us, too. I don't remember that at all. The first time we met was when Max Jacob introduced me to him, and Modigliani invited me to his studio at the Cité Falguière. At that time he was making sculpture, and of course I was especially interested to see what he was doing.

When I came to his studio—it was spring or summer—I found him working outdoors. A few heads in stone—maybe five—were standing on the cement floor of the court in front of the studio. He was adjusting them one to the other.

I see him as if it were today, stooping over those heads of his, explaining to me that he had conceived all of them as an ensemble. It seems to me that these heads were exhibited later the same year in the Salon d'Automne, arranged in step-wise fashion like tubes of an organ to produce the special music he wanted.

Modigliani, like some others at the time, was very taken with the notion that sculpture was sick, that it had become very sick with Rodin and his influence. There was too much modeling in clay, "too much mud." The only way to save sculpture was to start carving again, direct carving in stone. We had many very heated discussions about this, for I did not for one moment believe that sculpture was sick, nor did I believe that direct carving was by itself a solution to anything. But Modigliani could not be budged; he held firmly to his deep conviction. He had been seeing a good deal of Brancusi, who lived nearby, and he had come under his influence. When we talked of different kinds of stone—hard stones and soft stones—Modigliani said that the stone itself made very little difference; the important thing was to give the carved stone the feeling of hardness, and that came from within the sculptor himself: regardless of what stone they use, some

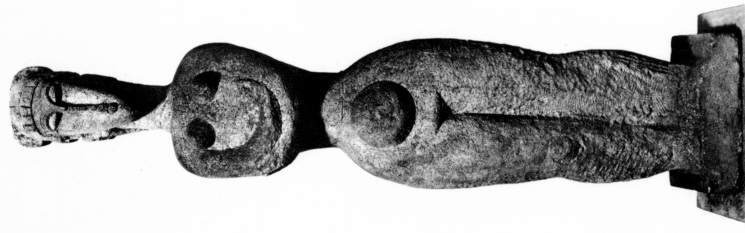

FIGURE
About 1910. Limestone, height 63"
Collection Mr. and Mrs.
Gustave Schindler, New York

baud—and more often than not he would recite by heart some of their verses. His love for poetry touched me, but I admired even more his obviously remarkable memory.

But now, when I think back to the time when I first met Modigliani, in the Luxembourg Gardens, I cannot dissociate that glorious scene—the Parisian sunshine, the beautiful greenness around us—from the tragic end of Max Jacob, the marvelous poet and delicate friend. When I heard about

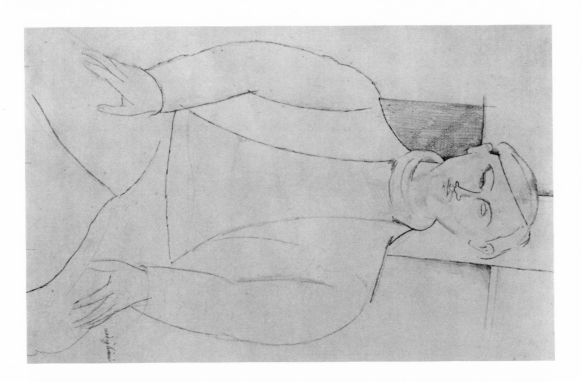

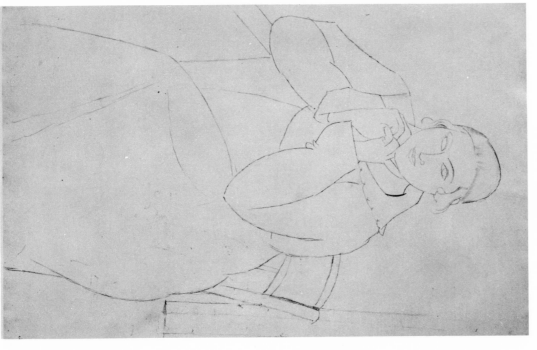

sculptors make their work look soft, but others can use even the softest of stones and give their sculpture hardness. Indeed, his own sculpture shows how he used this idea.

It was characteristic of Modigliani to talk like this. His own art was an art of personal feeling. He worked furiously, dashing off drawing after drawing without stopping to correct or ponder. He worked, it seemed, entirely by instinct—which was however extremely fine and sensitive, perhaps owing much to his Italian inheritance and his love of the painting of the early Renaissance masters. He could never forget his interest in people, and he painted them, so to say, with abandon, urged on by the intensity of his feeling and vision. This is why Modigliani, though he admired African Negro and other primitive arts as much as any of us, was never profoundly influenced by them—any more than he was by Cubism. He took from them certain stylistic traits, but he was hardly affected by their spirit. His was an immediate satisfaction in their strange and novel forms. But he could not permit abstraction to interfere with feeling, to get between him and his subjects. And that is why his portraits are such remarkable

characterizations and why his nudes are so sexually frank. Incidentally, I would like to mention two other artists whose work influenced Modigliani's style, and who are not often mentioned in this connection: Boldini, who years ago enjoyed the reputation of being one of Europe's most fashionable society portraitists, and Toulouse-Lautrec.

If Modigliani's convictions were strong, so were also his pride and his courage, which bordered almost on recklessness. I want to recall here one well-known incident which illuminates these traits in his character. Modigliani was not a physically strong man, yet one day in a café he attacked all by himself a gang of royalists, who in France are known for their soldierly courage. He wanted to fight them because he had heard them speaking against the Jews in a dirty way. Modigliani was naturally conscious of his Jewishness and could not bear any unfair criticism of a whole people. He was not urged on by political or other motives; it was just an inborn part of his personality. This was a very characteristic trend of his nature, understandable because he came from a very old Italian-Jewish family. His mother was a descendant of the great philosopher

far left:
JACQUES LIPCHITZ
1916. Pencil, 12 3/4 × 9"
Collection Jacques Lipchitz

left:
BERTHE LIPCHITZ
1916. Pencil, 22 × 15"
Collection Jacques Lipchitz

Spinoza; I heard him speak often about his mother, whom he adored and respected.

His judgment of the plastic arts was very good. It was he who helped Chaim Soutine, the painter, who at that time was known to only a few of us. And it was also he who induced Leopold Zborowski, his own dealer, to take an interest in Soutine's painting. Shortly before his death, a very sick man, Modigliani said to Zborowski, "Don't worry, in Soutine I am leaving you a man of genius." To understand this sentence better, one has to know more about the relationship between Modigliani and his dealer.

Leopold Zborowski, a Polish poet, poor but with a great love for art, was trying hard to make a living in the hungry Montparnasse at the beginning of the First World War. He bought and sold books and with the little he made on those operations he acquired paintings—first from his neighbor and friend, Kisling, and later, at Kisling's advice, he began to deal with Modigliani. Kisling was always a very good friend to

Modigliani. I saw Modigliani frequently working in Kisling's studio, using the latter's models and also his materials, and meeting the many people who came to see Kisling, a warm and generous comrade.

Little by little Zborowski became successful with his painters; he became known as the dealer of Modigliani, whose work in later years turned out to be a good source of income for him. That is why Modigliani, feeling his untimely end approaching, told Zborowski not to worry since he was leaving him Chaim Soutine, a painter of genius.

The connection between Modigliani and Zborowski is a remarkable example of the almost family relationship that existed between many artists and their dealers at that time in Paris. Not all the dealers were exploiters and slave-drivers. And the same was true for some collectors who were not at all thinking about investments when they bought a painting or sculpture. Some were real art lovers, like the charming M. du Tilleul whose portrait was done beautifully by Modigliani, or Alphonse Kann, who was trembling when he came to see my studio. So attracted was he when he discovered some new sculptures which he had not seen before that he would not leave my studio without taking them with him to his wonderful home. And there were many more like these two, with a genuine love for art.

In 1916, having just signed a contract with Leonce Rosenberg, the dealer, I had a little money. I was also newly married, and my wife and I decided to ask Modigliani to make our portrait. "My price is ten francs a sitting and a little alcohol, you know," he replied when I asked him to do it. He came the next day and made a lot of preliminary drawings, one right after the other, with tremendous speed and precision, as I have already stated. Two of these drawings, one of my wife and one of myself, are reproduced in this album. Finally a pose was decided upon—a pose inspired by our wedding photograph.

The following day at one o'clock, Modigliani came with an old canvas and his box of painting materials, and we began to pose. I see him so clearly even now—sitting in front of his canvas which he had put on a chair, working quietly, interrupting only now and then to take a gulp of alcohol from the bottle standing nearby. From time to time he would get up and glance critically over his work and look at his models. By the end of the day he said, "Well, I guess it's finished." We looked at our double portrait which, in effect, was finished. But then I felt some scruples at having the painting at the modest price of ten francs; it had not occurred to me that he could do two portraits on one canvas in a single session. So I asked him if he could not continue to work a bit more on the canvas, inventing excuses for additional sittings. "You know," I said, "we sculptors like more substance." "Well," he answered, "if you want me to spoil it, I can continue."

As I recall it, it took him almost two weeks to finish our

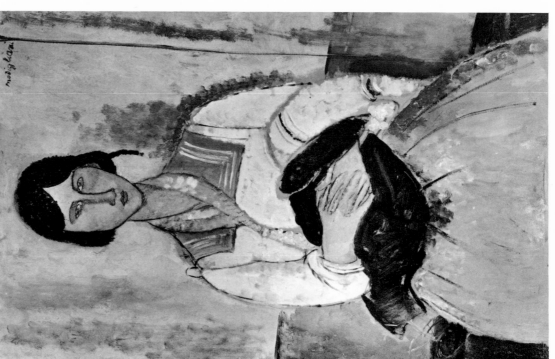

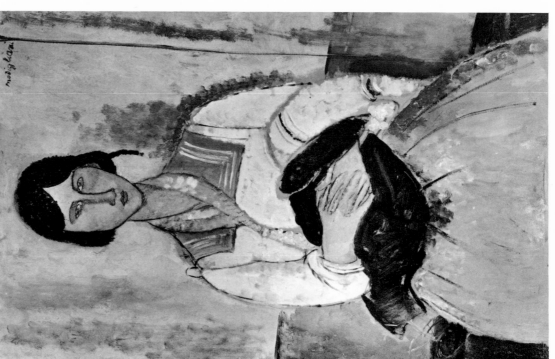GYPSY WOMAN
WITH BABY
1918. Oil, 45 × 28 3/4"
National Gallery of Art,
Washington, D.C.
(Chester Dale Collection)

8

portrait, probably the longest time he ever worked on one painting.

This portrait had been hanging on my wall for a long time until one day I wanted my dealer to return to me some sculptures in stone which I no longer felt were representative. He asked me more money than I could afford, and the only thing I could do was to offer as an exchange the portrait by Modigliani—who by that time was already dead. My dealer accepted, and as soon as I had my stones back I destroyed them. And that's how it happens that this portrait came finally to be in the collection of the Art Institute of Chicago.

It was two years later, in 1922, that the great American collector, Dr. Albert C. Barnes, discovered Modigliani as well as Soutine. (When I wrote these notes, I had just heard of the frightful death of this remarkable man, in an automobile accident.) In the apartment of Zborowski, 3 Rue Joseph Barat, Dr. Barnes bought a great many of their paintings. I remember the day very well, this day which caused a lot of noise on Montparnasse and will remain forever in the annals of art history. It was at this point that the two friends, Modigliani and Soutine, began to win international recognition. It was very appropriate for the Cleveland Museum of Art to reunite them early in 1951 in a splendid joint exhibition.

In the last years of his life Modigliani became increasingly devoted to Soutine, who had only a small studio but was always ready to share what he had with his friend. Modigliani's health was now completely undermined, his fits of coughing kept him from getting rest, and he drank more and more. Zborowski had scraped together some money to send him to Nice during the winter of 1919 for his health, but this did not help him. He was living at this time with Jeanne Hébuterne and their little girl in a small apartment. Little by little Modigliani's pictures were beginning to be sold, and we all hoped that a more ordered existence and better luck might yet be his. And then, in January of 1920, Kisling brought us the shocking news of his death.

Modigliani had been taken to the hospital one day, and the next day he was gone. We were told that on the way to the hospital he kept repeating "Italia! Cara Italia!" and that in his last moments of consciousness he fought wildly to hold on to life, babbling verses in his delirium.

And then came the tragic news of Jeanne Hébuterne's suicide. She was about nine months pregnant with another child by Modigliani, and when she arrived at the hospital morgue, she threw herself upon Modigliani and covered his face with kisses. She fought with the officials who pulled her away because they knew how dangerous it was for her—pregnant as she was—to touch the open sores that covered his face. She was a strange girl, slender, with a long oval face which seemed almost white rather than flesh color, and her blond hair was fixed in long braids; she always struck me as looking very

Gothic. Jeanne Hébuterne went to her father's house—she had been disowned for living with Modigliani—and she threw herself from its rooftop. Her family forbade that she be buried beside Modigliani, but I believe they were afterwards brought together.

Looking at his handsome likeness it is not difficult to understand that women were so crazy about him: Hébuterne, Beatrice Hastings, and others whose names we did not even know—including the little student girl who died of tuberculosis not long after Modigliani's death.

I will never forget Modigliani's funeral. So many friends, so many flowers, the sidewalks crowded with people bowing their heads in grief and respect. Everyone felt deeply that Mont-

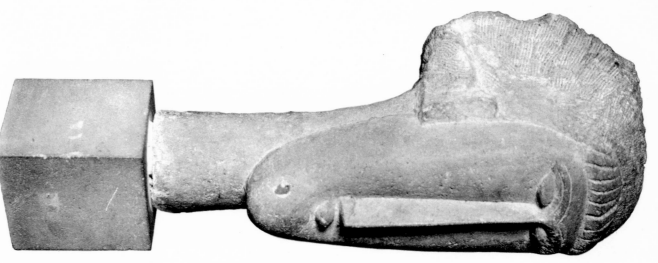

HEAD
About 1910. Limestone, height 25 1/2"
National Gallery of Art, Washington, D.C.
(Chester Dale Collection)

parnasse had lost something precious, something very essential.

Kisling and Moricand, a friend, tried to make Modigliani's death mask. But they did it very badly and came to me for help with a lot of broken pieces of plaster full of adhering bits of skin and hair. Patiently, I put the fragments together, and since many pieces were missing, I had to restore these missing parts as well as I could. Altogether I made twelve plaster molds, which were distributed among Modigliani's family and friends.

When he died Modigliani was far from being unknown. Paris was filled with strange and striking people, many with talent and some with genius, but he always stood out. And as I have said, it was not until 1922 that he began to be known internationally.

Up to that time Zborowski had worked hard and faced many difficulties in bringing his friend's work to the public. I remember two shows which Zborowski arranged in 1915 or 1916. One of them was in a small store near the Tuileries, and in it were several portraits of Zborowski done with the heavy impasto which Modigliani later abandoned. But Zborowski's most ambitious attempt during Modigliani's lifetime was a show he arranged in 1917 at the Berthe Weill gallery in the Rue Lafitte. To catch the eye of the public he had placed in the window four of Modigliani's nudes. Un-

fortunately it was the police who saw them first, and they made Zborowski take them out of the window. He came to me heartbroken. He had placed all his hopes in that show and now he was afraid that there would be nothing to draw people off the street into the gallery. He offered to sell the four nudes to me for five hundred francs, but what could I do with four nudes on my walls?

Some years later a nude by Modigliani—perhaps one of the four—was bought for close to a million francs by a French collector. Within a few years after his death Modigliani's paintings were eagerly sought for and collected, and their value is still increasing.

Compared with the life of a Titian or a Michelangelo Modigliani's life was a brief flash of brilliance. Would he have painted as well if he had lived a different kind of life, less dissipated and more disciplined? I do not know. He was aware of his gifts, but the way he lived was in no way an accident. It was his choice. One night during dinner I saw how ill he looked. He was eating in a strange way, almost covering his food with salt and pepper before even tasting it. But when I began to urge him to be less self-destructive and to put some kind of order into his life, he became as angry as I had ever seen him.

As I come to the end of this brief account I would like to say that although he died so young, he accomplished what he wanted. He said to me time and again that he wanted a short but intense life—"*une vie brève mais intense.*"

OPPOSITE PAGE:
THE CELLIST (*study*)
Commentary on page 40

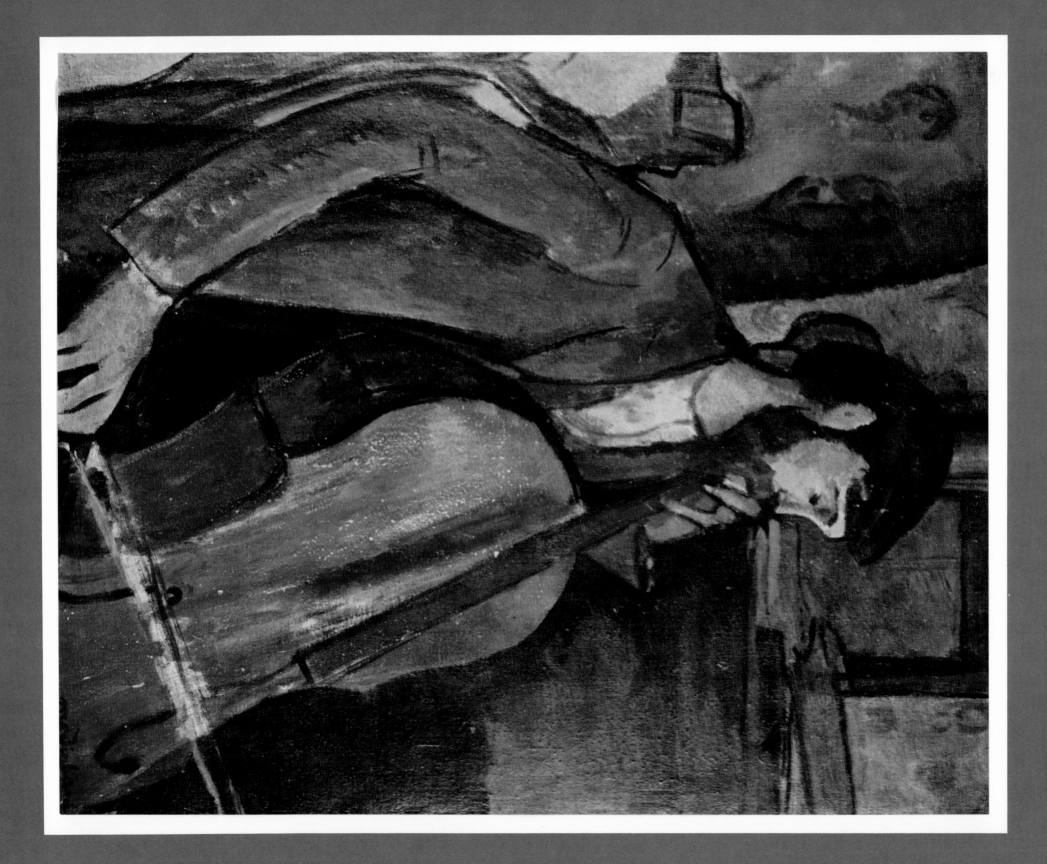

PAINTED ABOUT 1912

Caryatid

OIL ON CANVAS, 32 1/4 × 18"

COLLECTION ANTONINO VERDIRAME, MILAN

"CARYATID" is derived from the Greek word for a woman of Caryae in Laconia, Greece, and is applied to the sculpture of partly draped female figures which held up the roofs of ancient Greek temples. Similar figures were used to support the thrones of tribal chieftains of Africa's Ivory Coast. In this painting on the theme of a caryatid, Modigliani combined the influences of the two worlds to produce something witty and delicate. This picture was painted during the period when the artist was concentrating on sculpture. While only one sculptured caryatid by Modigliani has remained, and that in a very unfinished state, he drew and painted caryatids incessantly, in a large variety of poses.

12

PAINTED IN 1915

The Fat Child

OIL ON CANVAS, 18 1/2 × 15"

PRIVATE COLLECTION, MILAN

IN THE UPPER LEFT CORNER, the title *L'Enfant gras* is written in large characters. Modigliani occasionally painted the title on the canvas to identify the sitter or to convey an informal message. His friend and drinking companion Utrillo liked to use words like *vins* or *liqueurs* in signs on the old houses he painted. Picasso and Braque used words, or parts of words, as formal elements in their Cubist compositions. Although by 1915 Modigliani had abandoned his own sculpture, there is much sculpturesque simplicity in the pictures he painted in his last four or five years. The almost perfect oval of the face is reminiscent of the head of Mademoiselle Pogany done by Modigliani's mentor, the sculptor Constantin Brancusi. Salmon claims that *The Fat Child* "on closer inspection turns out to be a study of a beautiful young woman."

14

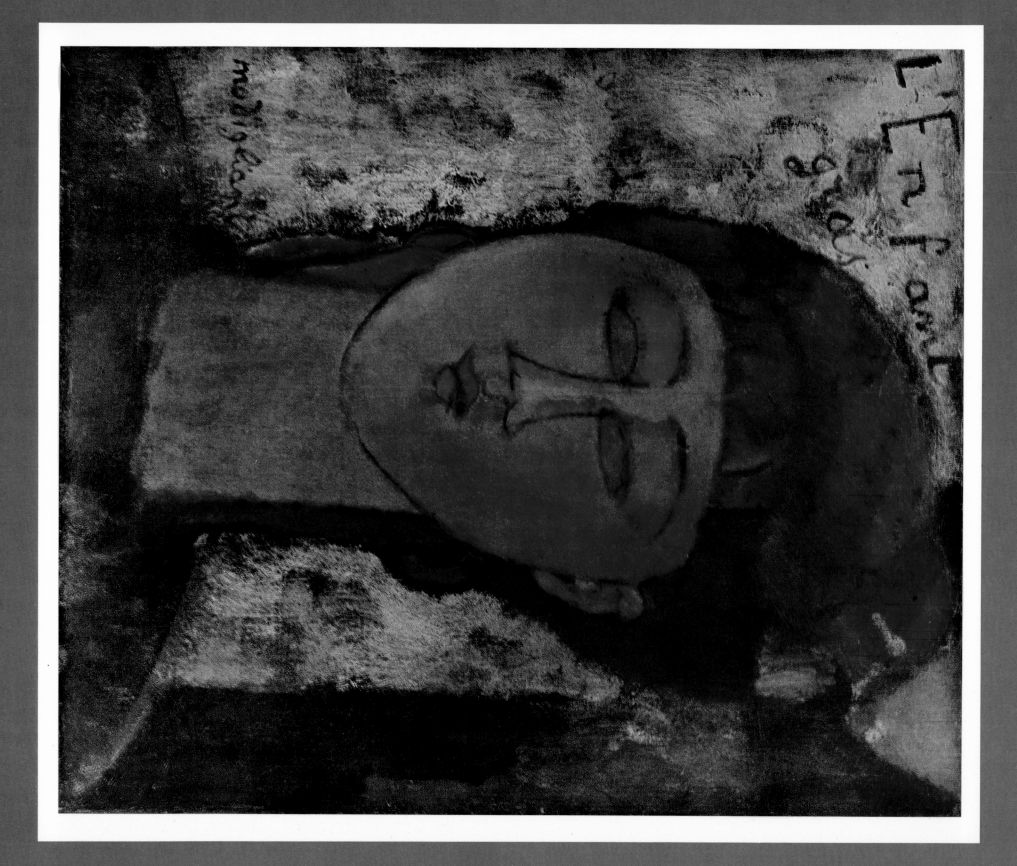

PAINTED IN 1915

Head of Kisling

OIL ON CANVAS, 14 1/2 × 10 3/4"

COLLECTION EMILIO JESI, MILAN

THE SITTER, the painter Moïse Kisling (1891–1953), has a four-square, strong-boned face and is portrayed in an uncompromisingly direct manner. Kisling studied first at the academy of art in his native city of Cracow (in Poland), where his well-informed teacher, Joseph Pankiewicz, strongly urged him to go to France: "He drew my attention to Paris, where the unhappy but ingenious Italian Jew, Amedeo Modigliani, had just started his ill-fated career, in reckless opposition to the *académiciens.*" Kisling arrived in Paris in 1910. He and his wife Renée often posed for Modigliani and tried to help him in many ways. When Modigliani had no studio, Kisling offered him his, in the Rue Joseph Bara. There Modigliani painted some of his masterpieces, among them the portrait of Jean Cocteau (page 23) and the double portrait of Lipchitz and his wife (page 21). Kisling assisted Lipchitz in making Modigliani's death mask.

Unlike Modigliani, who could be childishly rude to a prospective patron if he felt the slightest antipathy, Kisling was amiable in his dealings with collectors. He summed up his philosophy: "One works, eats, drinks, works, one lives very well and marries, that's all." His own portraits, strongly outlined and painted carefully in cool, restrained colors, have an affinity to those of Modigliani, but in them there is only a hint of melancholy, only a scent of sadness.

16

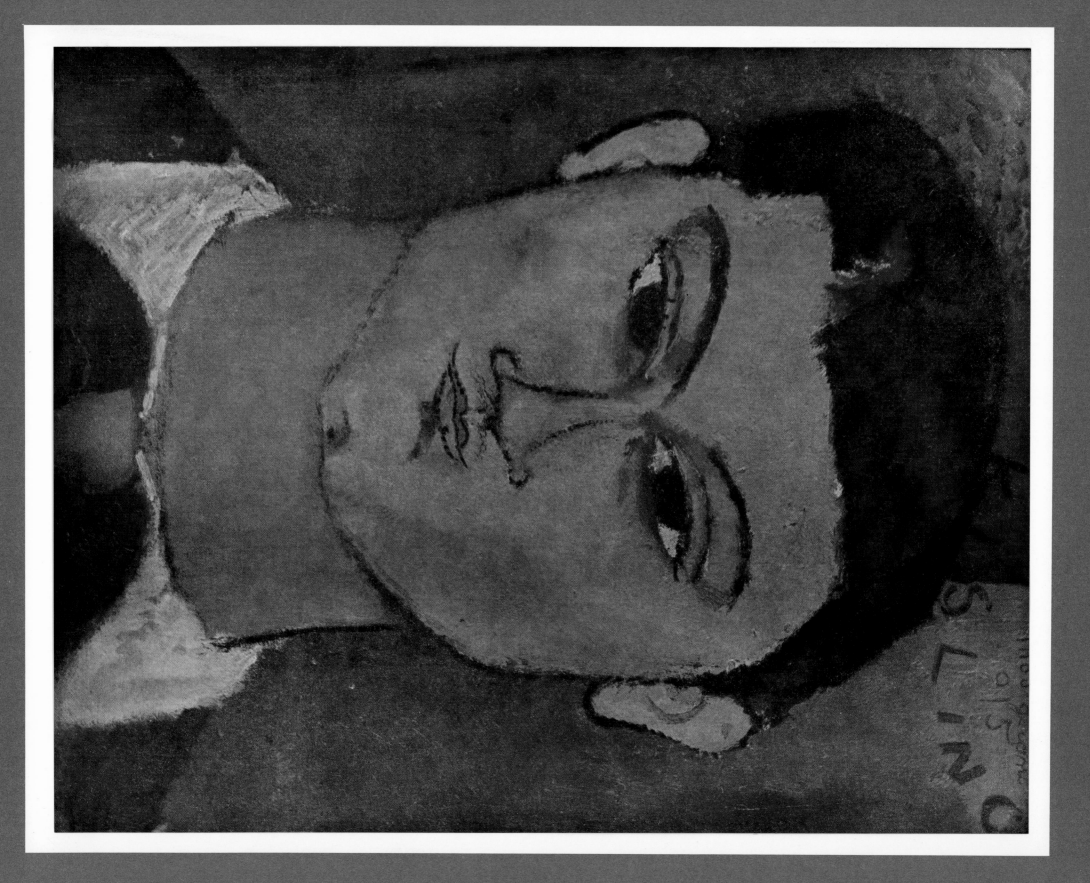

PAINTED IN 1916

Portrait of Paul Guillaume

OIL ON CANVAS, 31 1/2×21 1/4"

CIVICA GALLERIA D'ARTE MODERNA, MILAN

THE POET MAX JACOB introduced Modigliani to the dealer Paul Guillaume in 1914. (Guillaume opened his own gallery on the Rue du Faubourg St. Honoré in 1915.) He bought and sold some of Modigliani's paintings, yet did not devote himself to the young artist with the self-forgetting fervor that was to characterize the next and last dealer, Leopold Zborowski. Modigliani drew and painted Guillaume several times. In another portrait, now in a private collection in Paris, the words "NOVO PILOTA" appear in the lower left corner. They were meant as a compliment, a comparison of the *avant-garde* dealer with pioneer aviators. In pose this picture is reminiscent of Venetian Renaissance portraits the artist must have seen in his student days. By little details—the tilt of the hat and the necktie slightly off center—Modigliani characterizes his dealer as easygoing and informal, as he assuredly was. But there is also something detached and subtly arrogant in the posture and facial expression of this businessman who later committed suicide by shooting himself.

18

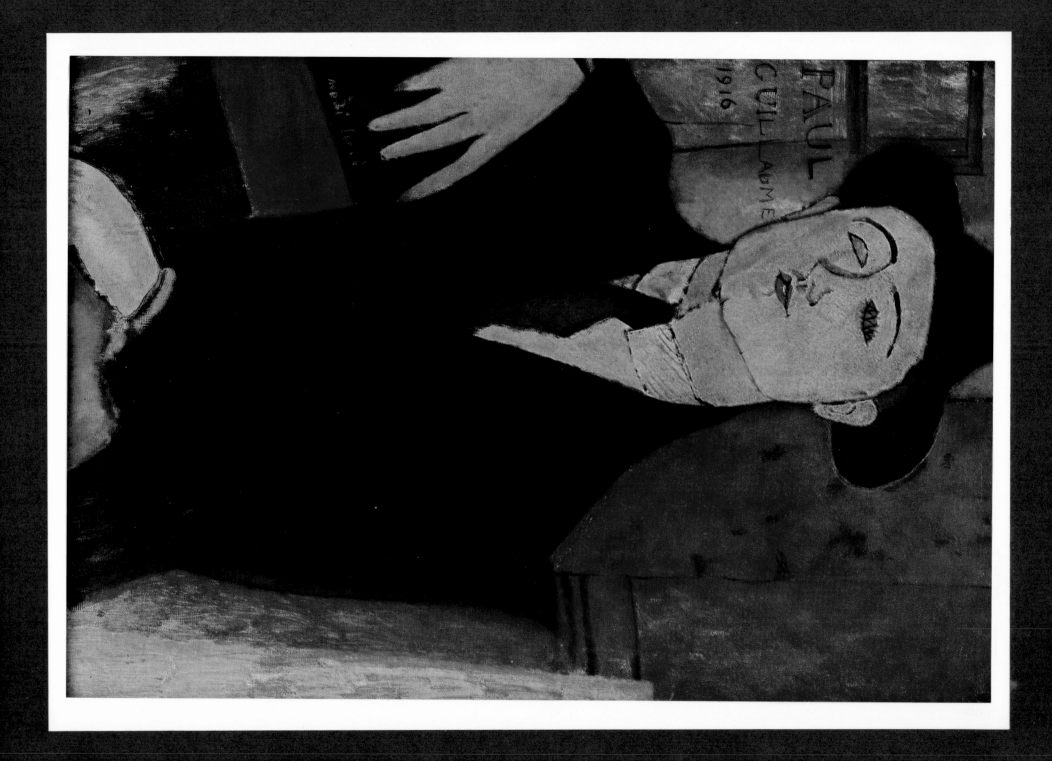

PAINTED 1916–17

Jacques Lipchitz and His Wife

OIL ON CANVAS, 31 1/2×21″

THE ART INSTITUTE OF CHICAGO
(*Helen Birch Bartlett Memorial Collection*)

THIS IS ONE OF MODIGLIANI'S PORTRAITS with more than a single figure, and the only double portrait whose sitters are known, and indeed famous. Since Lipchitz explains the genesis of this painting in his text (page 8), only a few additional details need be added here.

At the time it was painted, Lipchitz was producing some of his finest Cubist stone sculptures, such as *The Man with a Guitar* (Museum of Modern Art, New York) or *The Bather* (Barnes Foundation, Merion, Pennsylvania). The sculptor's new bride, Berthe (née Kitrosser), a poetess, was said to look like "a bright Russian doll." On Sundays, as often as their finances permitted, the young couple entertained their artist friends and Berthe achieved renown as an excellent Russian cook.

Among their regular guests was Modigliani. He looked emaciated, coughed heavily, and was obviously in dire need of money. Deeply concerned, Lipchitz wanted to help his friend and did so by commissioning this double portrait. Modigliani commenced by making about twenty preparatory drawings; Lipchitz kept some (two are shown on page 7); others he gave to friends. In one of the drawings in this book, Lipchitz is seated in the relaxed position he still assumes to this day: legs straddled, hands resting on thighs. Modigliani is reported to have begun this sketch in a curious way, starting with the eyes, and then rapidly drawing in everything around them.

The Bolshevik Revolution prevented Lipchitz from sending the painting to his parents in Lithuania as he had planned; its subsequent fate is related in the text (page 9). Though this double portrait was painted in the freely mannerist style that Modigliani developed to perfection by 1918, it is a good likeness, to judge by the photographs reproduced in A. M. Hammacher's book on the artist (Abrams, 1960).

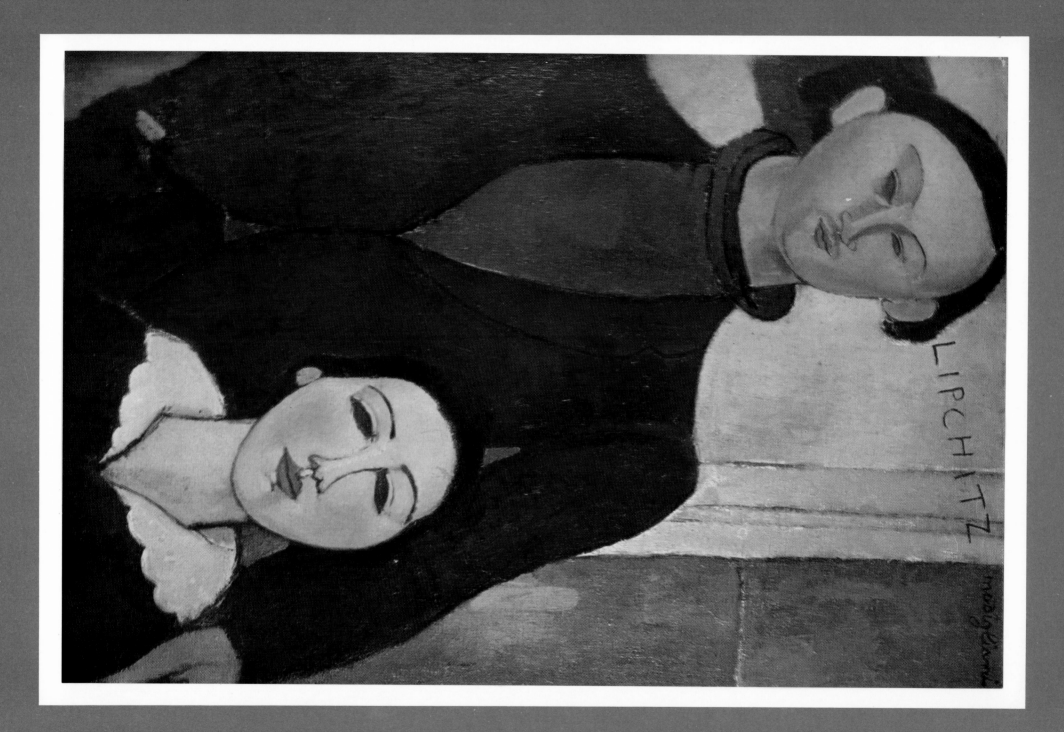

PAINTED IN 1917

Portrait of Jean Cocteau

OIL ON CANVAS, 39 1/2×32"

COLLECTION HENRY PEARLMAN, NEW YORK

CLOUET AND THE FRENCH SCHOOL OF PORTRAITURE come to mind in this delicate portrait of the elegant young poet Jean Cocteau (1889–1963), then well known for his association with the Russian Ballet. Cocteau sits here as a perfect dandy—note the carefully arranged white handkerchief in his breast pocket. The high hoop of the chair, reminiscent of a throne, might have been chosen by the artist to indicate the leadership the poet, despite his youth, exerted over the literati of Paris.

In the introduction to a small volume on Modigliani, Cocteau called him "our aristocrat." The two became close friends during the painting of this portrait: "I had a sitting every day at three o'clock in Kisling's studio. . . . Modigliani's portrait (his prices were between five and fifteen francs) has traveled widely, and enjoyed an immense success; but we were not then concerned with the results of our actions; none of us saw things from the historical viewpoint—we merely tried to live, and to live together."

In this angular, quasi-Cubist portrait Modigliani proved again how well he could, through subtle observations, point out important character traits.

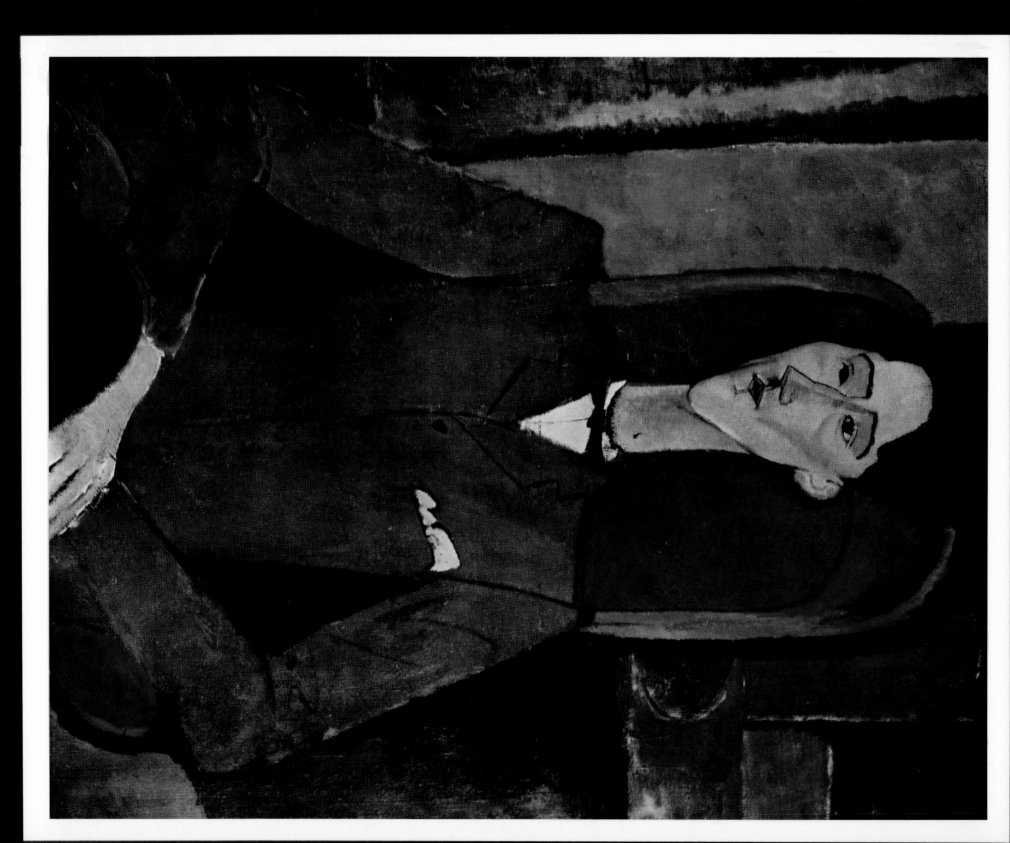

PAINTED IN 1917

Le Beau Major
(Dr. Devaraigne)

OIL ON CANVAS, 22 × 19"

COLLECTION THE EVERGREEN HOUSE FOUNDATION, BALTIMORE

WE KNOW LITTLE about the bearded sitter, a physician, except that Modigliani consulted him several times. He seems to have been an army surgeon, to judge by the title, the blue uniform, and the decoration he wears on the left breast. The ruddy complexion is set off by the russet colors of the wall. The general treatment recalls Van Gogh's portrait of the postman Roulin. In all likelihood, Modigliani owned reproductions of Van Gogh's work: the Dutch painter was very popular with the younger artists of Paris. Another portrait of Dr. Devaraigne by Modigliani is in the famous collection of Emil G. Bührle, Zurich.

24

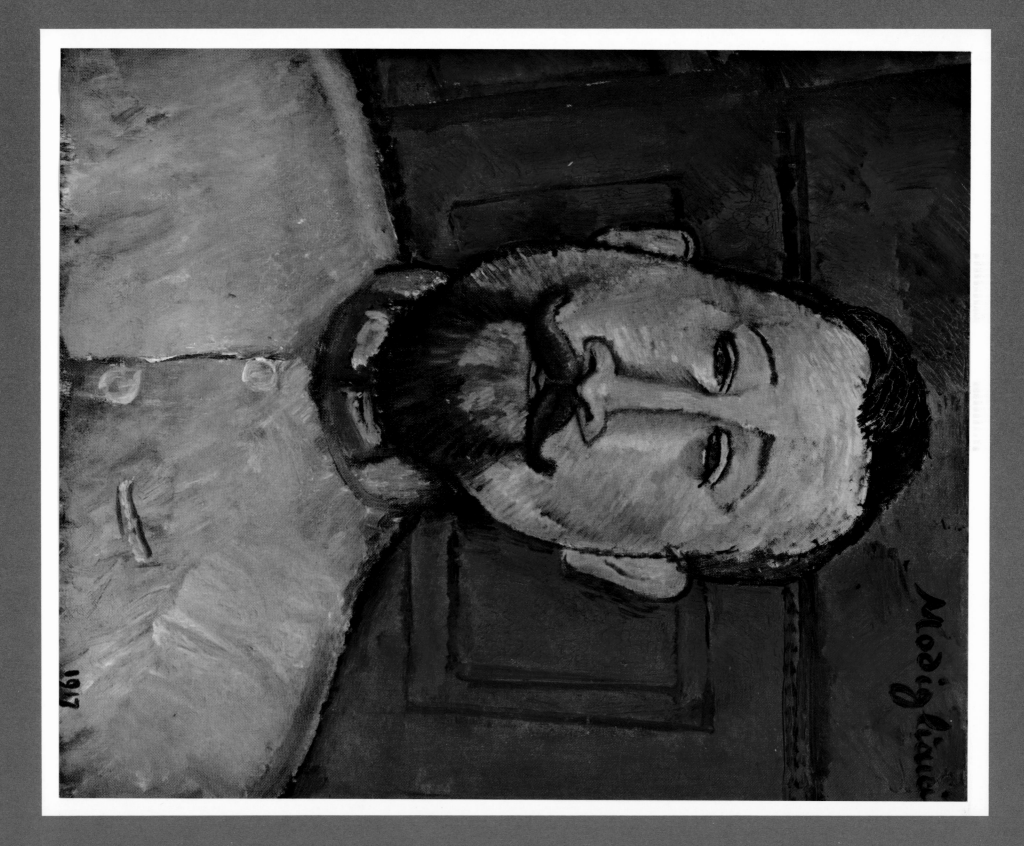

PAINTED 1917–18

Nude on a Cushion

OIL ON CANVAS, 23 1/2×36 1/4"

COLLECTION GIANNI MATTIOLI, MILAN

SLEEPY AND TRANQUIL, the young woman lies stretched out on the sofa, her body forming a long diagonal across the picture. There is no false modesty about Modigliani's anonymous models, who, aware of the artist's presence, display themselves fully to him and to us. Degas, striving to obtain the same unconscious freedom in his work, said that he painted his nudes, bathing and scrubbing themselves, as though he had watched them through a keyhole.

Studying the unrestrained voluptuousness, Modigliani made many pencil sketches, tenderly outlining each limb. He then turned to the canvas on the easel, filling the graceful arabesques which define the form with terra-cotta flesh tones of the most lustrous quality. The elongated body stands out superbly against the subtle combinations of red, blue, black, white, and brown in the background.

The biographer G. Scheiwiller has written:

"One does not know nudes like those of Modigliani's, which can demonstrate such a perfect spiritual communion between the painter and the creature chosen as model."

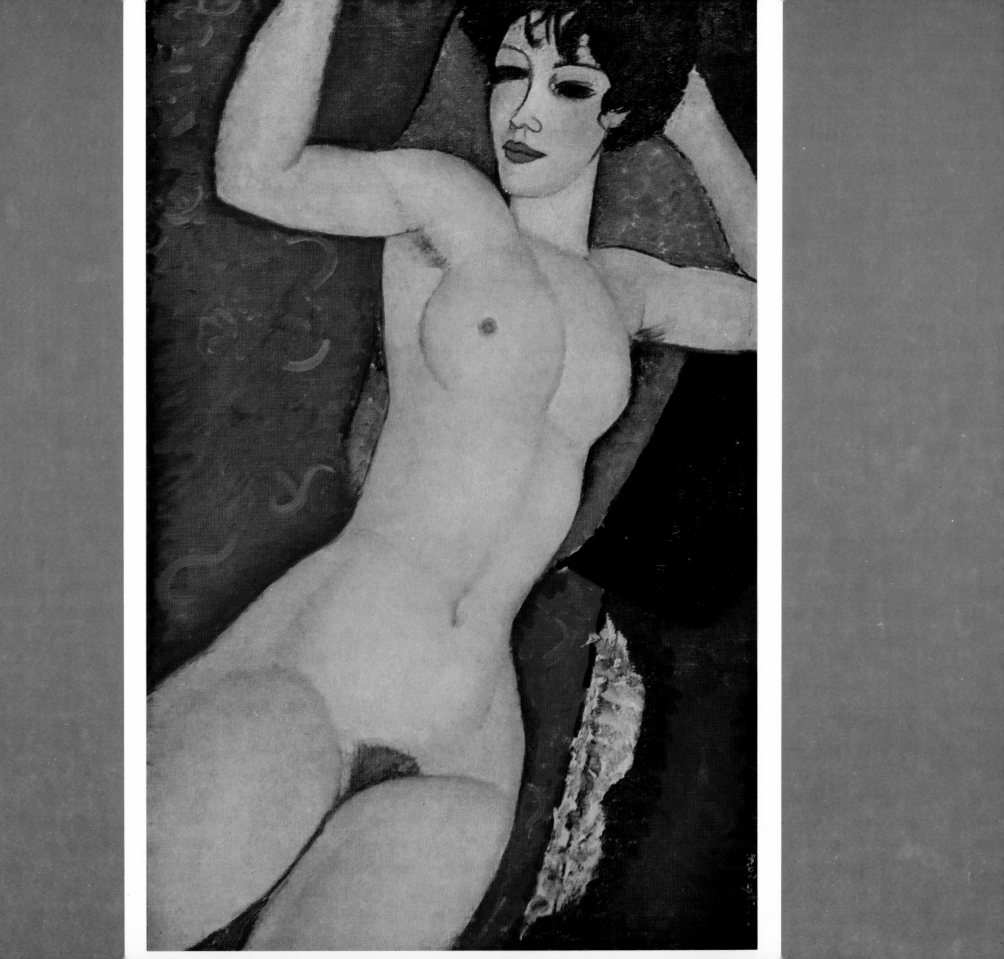

PAINTED 1917-18

Portrait of Marguerite

OIL ON CANVAS, 31 1/2 × 17 3/4"

THE ABRAMS FAMILY COLLECTION, NEW YORK

THE SAME MODEL in the same mauve dress posed in strict frontality for another picture, now in a private collection in Italy. The room is barely indicated by what looks like a door, and space is suggested only by the perspective of the chair. While many of Modigliani's male sitters are known to us, and include individuals who achieved high fame in art or literature, this is less true of the female sitters, often identified by first name only—such as Louise, Almaisa, or Renée—or not identified at all. Marguerite was one of the thousands who frequented Montmartre and Montparnasse trying to eke out a living. The artist gave her a strength of character she may not have possessed. Note the exaggerated size of the vivid eyes and the uninterrupted elegant line that encompasses the outline of the nose and eyebrow.

Carrieri observes: "Men and women repeat the same natural gesture; sitting down is the simplest thing in the world; but when they stand up again, they have unknowingly left their soul there. The chair, the plaster, the atmosphere is pregnant with them. . . ."

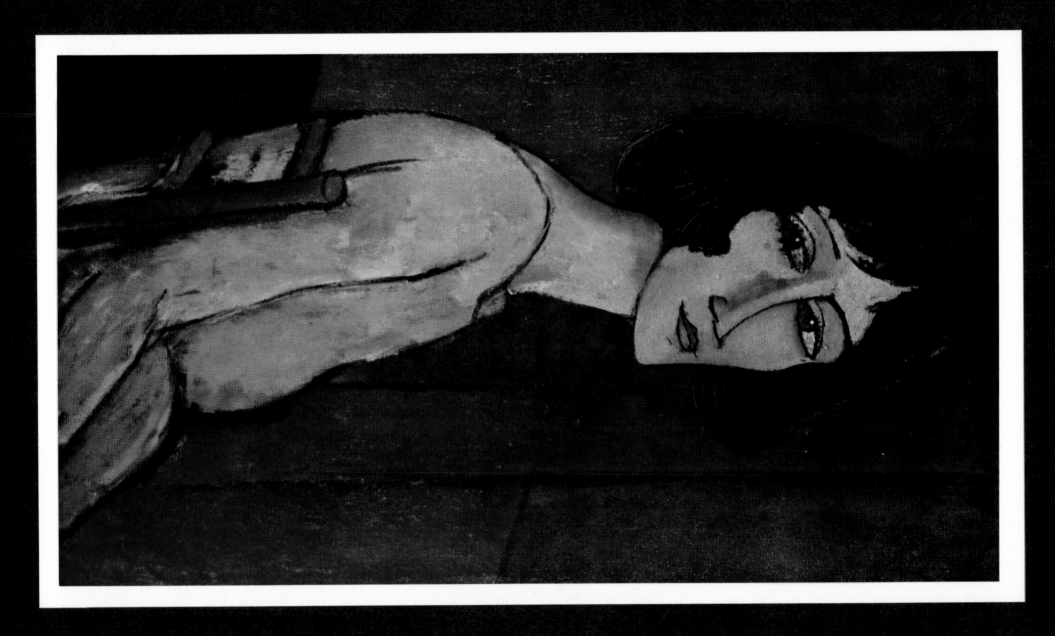

PAINTED IN 1918

Seated Nude

OIL ON CANVAS, 32 1/2 × 26 3/4"

COLLECTION MR. AND MRS. LEIGH B. BLOCK, CHICAGO

THE ARTIST HAS PLACED THE FIGURE on his canvas in such a way that the head and large hips balance one another—with the thighs as a kind of double statement of shapes roughly corresponding to the shape of the face. Even though the body is clearly a combination of elementary stereometric shapes—interlocking cylinders, spheres, and ovoids—Modigliani's nudes are, on the whole, more realistic and less stylized than his portraits. Here the notion of nudity is enhanced by the proximity of the bit of white cloth (a discarded garment or a pillow case?) and the direct confrontation of the model. The sensuality of the figure is enhanced by the deliberate, concealing position of the crossed hands, yet the voluptuousness is always kept under control. The dignity of immaculate style elevates this subtly erotic nude to a higher level of aesthetic contemplation. Modigliani had no trace of the misogyny of Degas, the lewdness of Bouguereau, the clinical coldness of Toulouse-Lautrec, or the cynicism of Pascin.

He loved women, without reservations, and makes the spectator also love them. In his book, *The Nude*, Sir Kenneth Clark wrote that "no nude, however abstract, should fail to arouse in the spectator some vestige of erotic feeling . . . and if it does not do so, it is bad art and false morals."

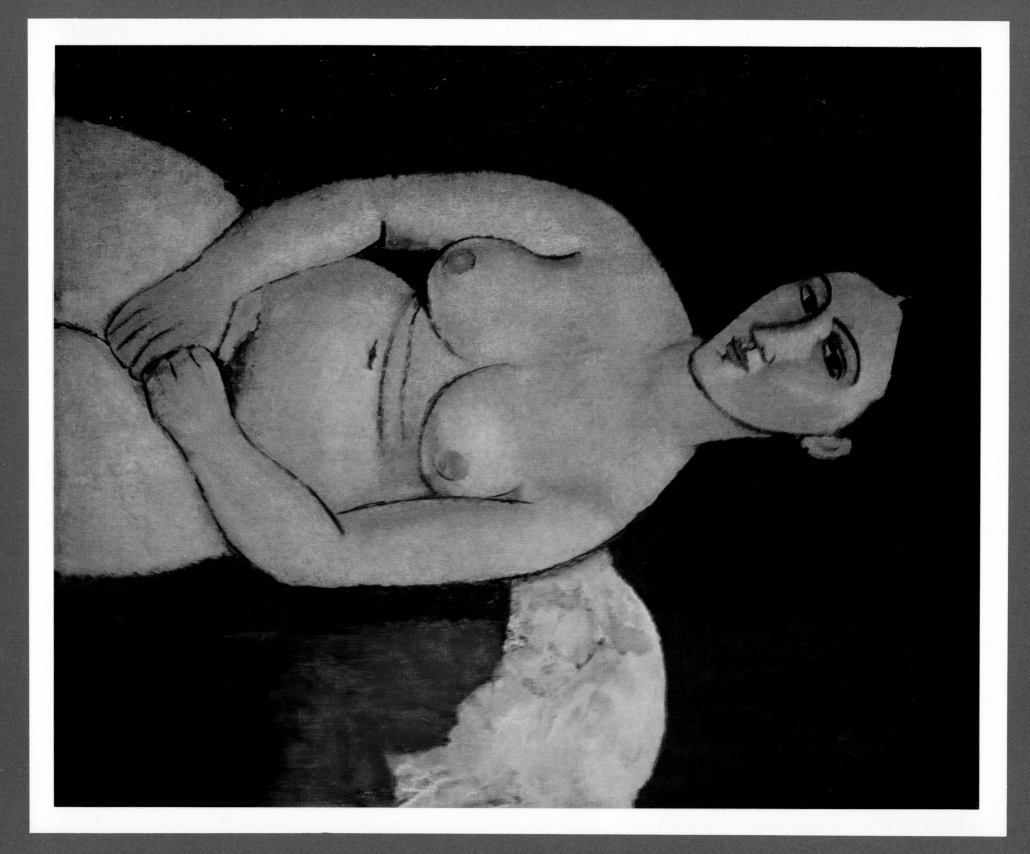

PAINTED IN 1917

Girl with Braids

OIL ON CANVAS, 23 1/4 × 17 1/4"

COLLECTION DR. AND MRS. ERNEST KAHN,
CAMBRIDGE, MASSACHUSETTS

THIS IS ONE OF MODIGLIANI'S MOST POPULAR PAINTINGS. Here "distor-
tions" and "exaggerations" are less noticeable. The geometric patterns are care-
fully balanced. While the pretty face is more naturalistically drawn and painted than
in other portraits—even to the light reflected in the pupils—the shoulders droop
rather unnaturally and the torso becomes a sort of stele for neck and head. Like his
contemporary Jules Pascin, Modigliani seems to have been fond of children, for he
painted quite a few schoolgirls and boys. This gay little girl in pigtails, with raised
eyebrows, whose white teeth repeat the stark whites of her eyes, is as yet untinged
by the sordidness of the milieu in which she lives. The door in the background is a
favorite motif.

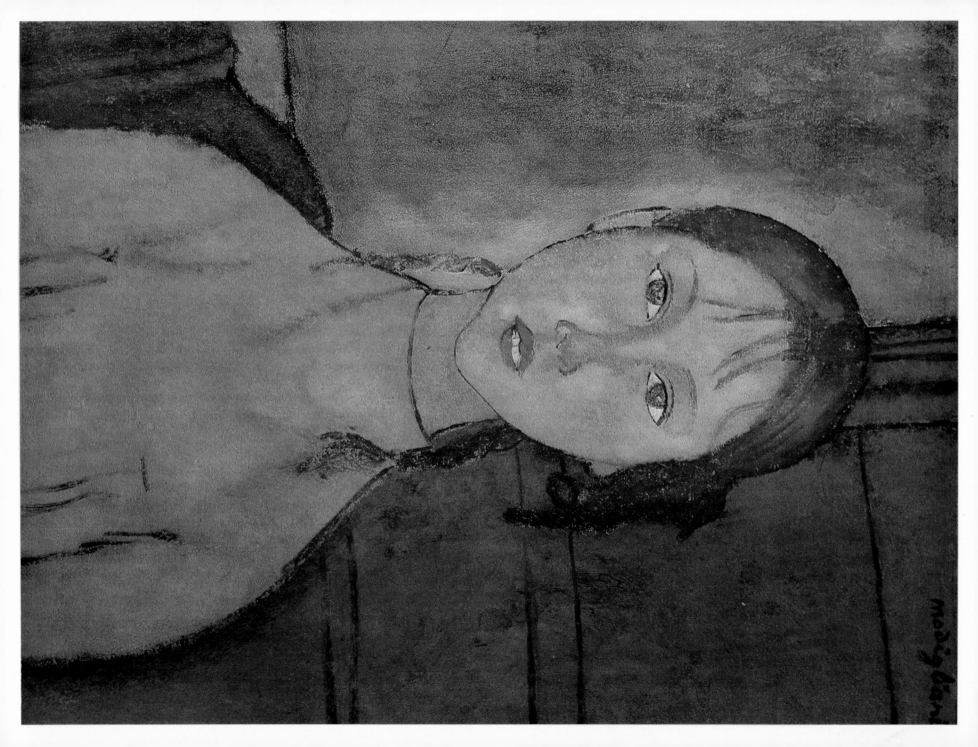

PAINTED IN 1919

Portrait of Lunia Czechowska

OIL ON CANVAS, 18 1/2 × 13"

PRIVATE COLLECTION, MILAN

THE SITTER, A FRIEND OF THE ZBOROWSKIS, first met the artist in June, 1916. In every possible way she tried to assist Modigliani, and subsequently Jeanne Hébuterne as well. The artist drew and painted her aristocratic Slavic features repeatedly; among Modigliani's best-known pictures is one, now in the Petit Palais, Paris, of Madame Czechowska in a yellow dress and holding a fan. Ambrogio Ceroni's *Amedeo Modigliani, Peintre* includes Madame Czechowska's memoirs, written in 1953. She says of Modigliani, "I was struck by his distinctive appearance, his radiance, and the beauty of his eyes.... Modigliani saw only that which was beautiful and pure." Modigliani, she continued, was "determined to capture his or her character and to implant it in his work. As for the model, he or she had the impression of having the soul laid bare and of being in the strange position of being able to do nothing to disguise the feelings."

This is one of Modigliani's most beautiful and most celebrated portraits. The figure is drawn firmly, with incisive strokes, against the bare wall. Like the sixteenth-century Mannerists of his native country, Modigliani here asserts his independence from nature by freely exaggerating and distorting, while maintaining a balance between naturalism and abstraction. His passion for beauty, his desire to avoid the ordinary, and his search for intellectual grandeur did not conflict with his yearning for truth about the sitter. While one admires the spiritual elegance and crystalline perfection of this picture, one becomes fully aware of Madame Czechowska's dignity, her serenity tinged with a touch of sadness.

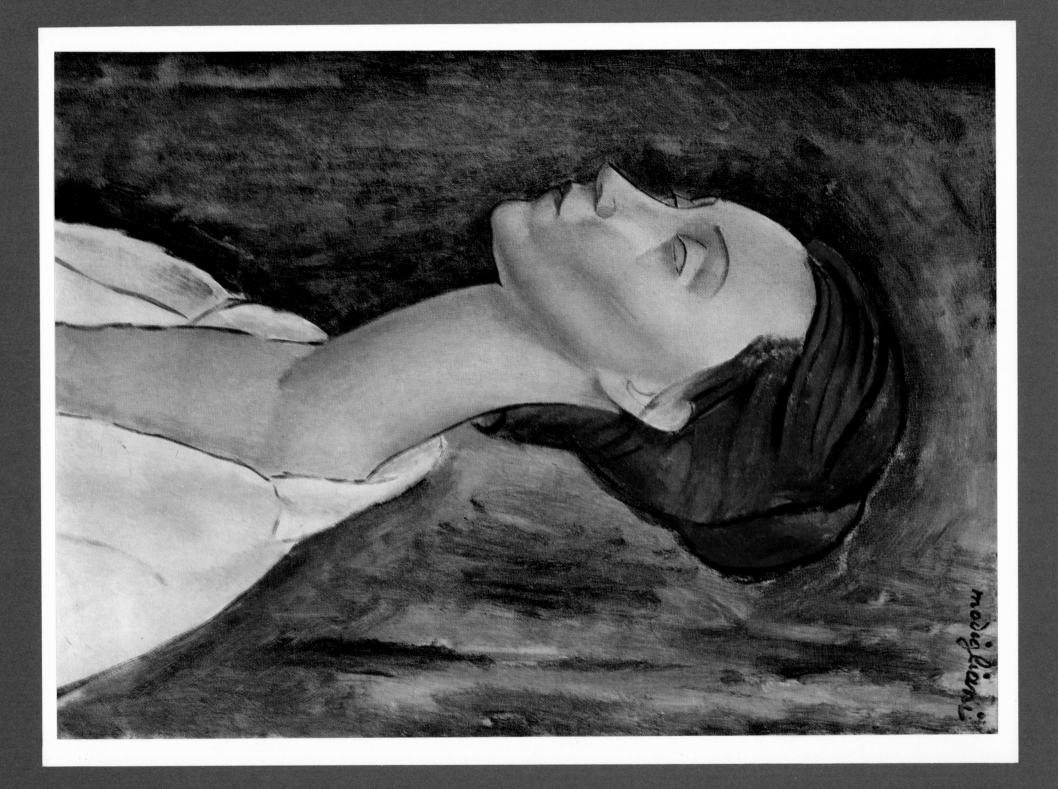

PAINTED IN 1919

Self-Portrait

OIL ON CANVAS, 33 1/2×23 1/2"

COLLECTION MRS. YOLANDA PENTEADO MATARAZZO, SÃO PAULO, BRAZIL

THE PAINTER who has never tried to fix his own likeness onto canvas is rare; many artists have painted themselves repeatedly, at different stages of their careers —Rembrandt and Van Gogh in particular come to mind. Unfortunately, we have only this self-portrait of Modigliani, posed conventionally enough with palette and brush. (There exists a fanciful "portrait," in Pierrot costume, dated 1915, in the Statens Museum for Kunst, Copenhagen.) Surprisingly, no portraits of Modigliani appear to have been made by his famous colleagues, although he knew and painted Picasso, Rivera, Kisling, Soutine, and others. Photographs show Modigliani as a handsome man with decidedly Mediterranean features; his face was not especially long, and not as thin as in this picture. Salmon writes that most of his Parisian friends mistook him for an athlete, not knowing that he had been tubercular since childhood. Yet Modigliani would not be expected to revert to photographic realism in painting his own features. He had early achieved his own style, with its characteristic elongation, abbreviations, and distortions. And since this picture was painted not long before his death, sickness and privation may have made him as gaunt and thin as he appears here. (It has a disturbing likeness to the death mask taken not long after by Lipchitz.) Modigliani's aristocratic bearing and spiritual refinement are captured in this portrait.

Jean Cocteau, who posed for Modigliani, remarked, "Modigliani's portraits, even his self-portraits, are not the reflection of his external observation, but of his internal vision, of a vision as gracious, noble, acute, and deadly as the fabulous horn of the unicorn."

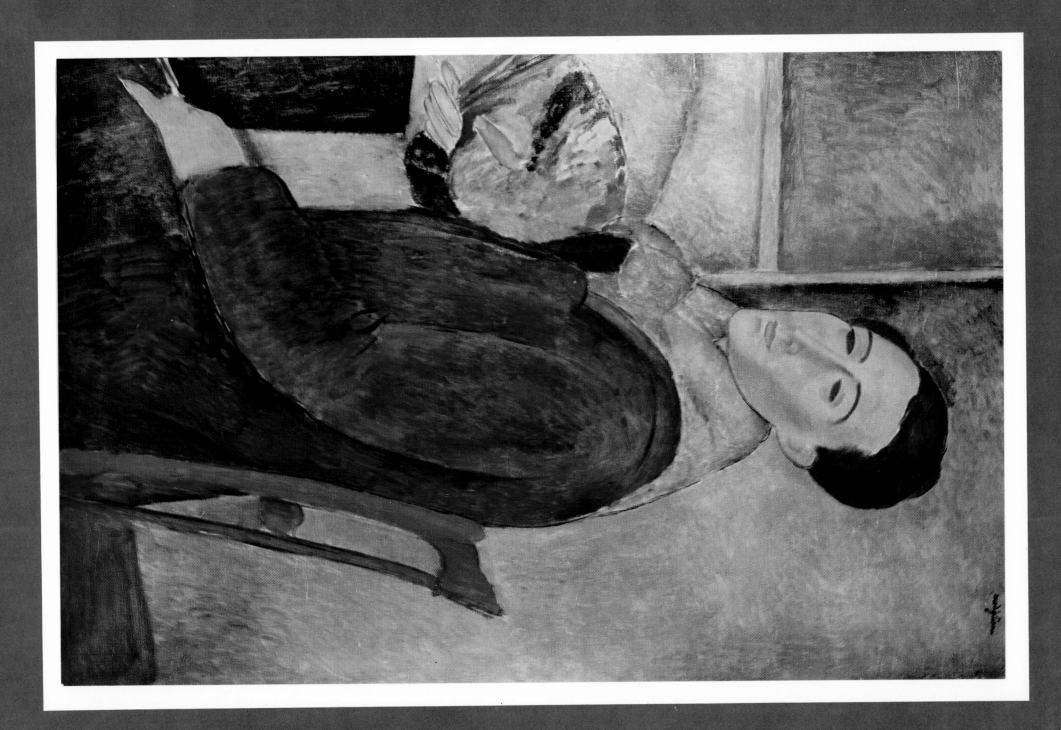

PAINTED IN 1919

Portrait of Jeanne Hébuterne

OIL ON CANVAS, 51 1/4×32"

COLLECTION MR. AND MRS. SYDNEY F. BRODY,
LOS ANGELES

HERE THE SITTER IS POSED BEFORE A DOOR. This is one of Modigliani's last pictures—it may have been the very last. Jeanne reveals the first signs of the approaching maternity; she was expecting their second child, destined to die unborn in Jeanne's suicide. Rightly regarded as one of the finest pictures Modigliani ever painted, it has what has been called *eleganza tutta Toscana*. The suffering yet patient woman is painted with unmistakable warmth and understanding, in all her childlike withdrawal into herself from a hostile world. Here, spiritualization reaches a new height. Christian Zervos has written about the artist's last works that they "changed little in form or technique; we find in them only changes towards a greater penetration in the quality of sentimental perception which unites and fuses the whole picture—whereas in earlier works the emotion was often localized."

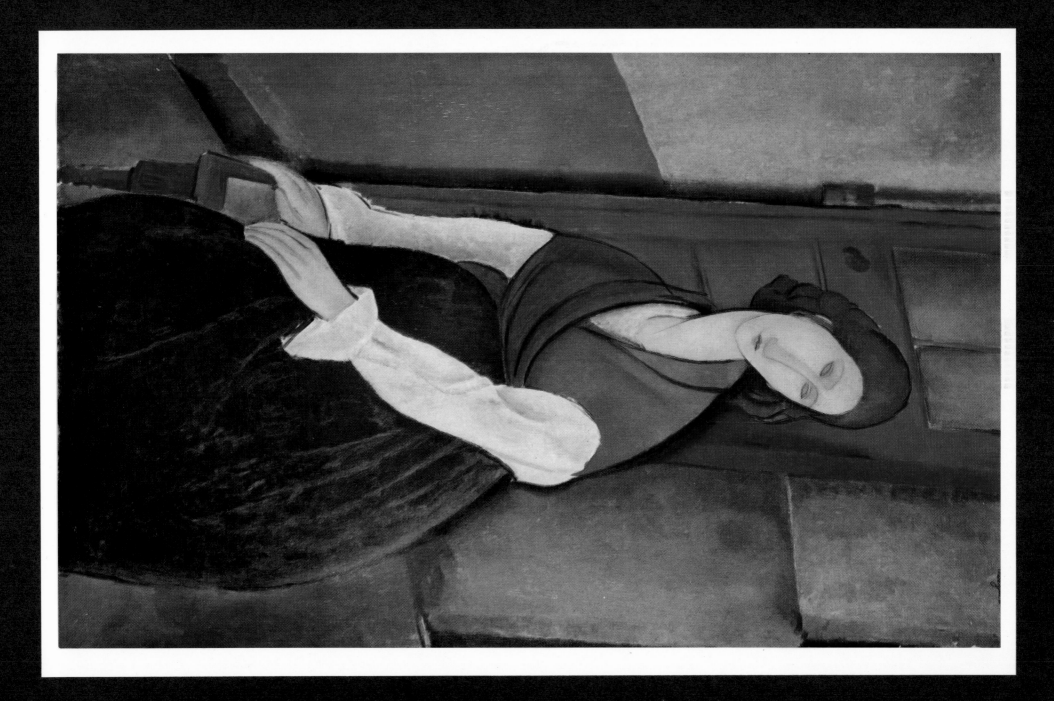

ON PAGE 11:

PAINTED IN 1909

The Cellist

OIL ON CANVAS, 29×23 1/2"

PRIVATE COLLECTION, PARIS

WHEN SOMEBODY POINTED OUT to Max Liebermann that in Cézanne's *Boy in a Red Vest* one arm was much too long, the German master replied, in Cézanne's defense, "Such a superbly painted arm can't be long enough!" In this picture, which clearly reveals Cézanne's influence, several "unnatural" elongations can be noted; yet, far from disturbing the beholder, they increase his feeling for the picture's inwardness. The bearded young cellist does not look at us; he is too deeply involved in making music to pay attention to anything but his instrument. Incidentally, the cello player—whose instrument has the leading role in the picture—was a poor devil who lived at the Cité Falguière when Modigliani had a studio there; the posing gave him a chance to keep warm at Modigliani's stove.

Though this majestic picture is listed as a "study" (*étude*), one feels that it is complete, even if certain areas of the canvas have remained without pigment and the bow is barely indicated. There also exists a somehow more "finished" version. Both versions were first shown in 1910 when Modigliani participated with six pictures in a group show of the Salon des Artistes Indépendants, for the second and last time. In 1926, the more finished version was seen again in the show Trente Ans d'un Art Indépendant, given by the Société des Artistes Indépendants, which also included, among others, *The Jewess* and the portraits of Paul Guillaume (page 19) and Jean Cocteau (page 23). On the back of the canvas reproduced here is sketched a portrait of Modigliani's friend and mentor, the sculptor Constantin Brancusi.